THE NATIONAL MUSEUM OF
AFRICAN AMERICAN HISTORY & CULTURE

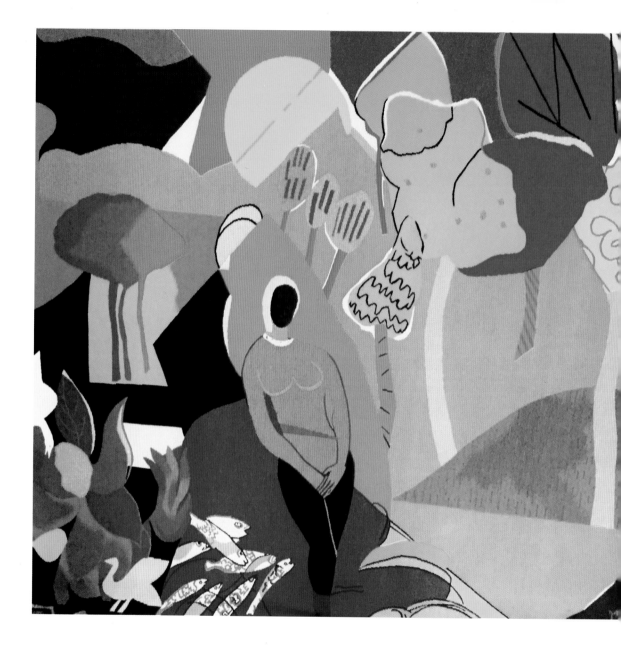

THE NATIONAL MUSEUM OF
AFRICAN AMERICAN
HISTORY & CULTURE
A SOUVENIR BOOK

SMITHSONIAN BOOKS
WASHINGTON, DC

ABOUT THE MUSEUM

THE NATIONAL MUSEUM OF AFRICAN AMERICAN HISTORY AND CULTURE IS NOT only a place that honors the nation's legacies of freedom and equality, but also one that helps Americans to remember. By remembering, we stimulate a dialogue about race in America and help to foster a spirit of reconciliation and healing. By remembering, we honor those who made history and have helped make our nation what it is today—a democratic society that needs to recall its past while striving to live up to its highest ideals.

This museum has its roots in 1916, when African American Civil War veterans sought to establish a memorial building on the National Mall. Their goal was to commemorate "the men and women of our Race whose deeds entitle them to honorable mention." They envisioned a place where all were welcome to witness the tremendous service, ingenuity, and creativity that African Americans have contributed to American history and culture.

Now that the moment is finally here, I am thrilled to present this book of images from the National Collection. Artifacts that both bring our nation's history to life and ground us in that history—artifacts used, made, and treasured by the makers of history—are sampled here. These are highlights of this museum that you can take home and remember.

Lonnie G. Bunch III
Founding Director, National Museum of African American History and Culture

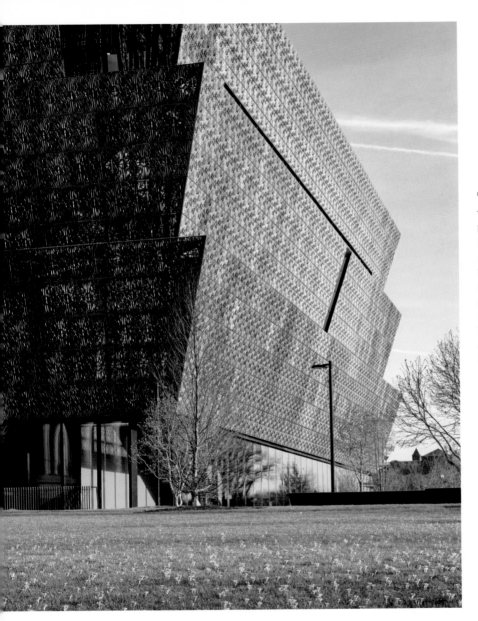

The 390,000 crocuses
blooming on the
Museum's lawn
not only set off the
bronzed surface of
the building, but also
recall the blue beads
traditionally used
in African American
amulets to symbolize
hospitality.

THE COLLECTION

WHEN THIS MUSEUM WAS FIRST CREATED, MANY WONDERED IF IT WOULD BE possible to gather materials sufficient to establish a National Collection. Building a collection to represent "a people" is a challenge for any museum, and it seemed especially daunting in light of our nation's history of slavery and oppression. However, African Americans have been documenting and collecting their history and culture since the 1800s, recognizing the need to save what others did not value. Building on these traditions, by the opening of the National Museum of African American History and Culture, the collection numbered more than 34,000 items. The Museum has gathered—with the help of more than a thousand gifts by individual donors—a collection of national stature that helps us to explore the long arc of African American experience.

This sampling of the Museum's collection reveals the richness of the African American material culture that has been gathered to explore that experience. Our goal has been to display iconic objects of African American history as well as to develop a strong photography collection depicting pivotal moments along with striking portraiture. We have sought objects of the famous and highest achievers in our culture, but also materials reflecting the experiences of ordinary people. By collecting art, we are illustrating the critical role that American artists of African descent have played in shaping the history of American art.

James Baldwin stated, "American history is longer, larger, more various, more beautiful, and more terrible than anything anyone has ever said about it." What we begin to say with the stories in this museum and with these artifacts is that the African American experience is the quintessential American experience. The artifacts here speak to each visitor in a unique way that helps all of us to understand the very human stories behind them.

Michèle Gates Moresi
Museum Curator of Collections

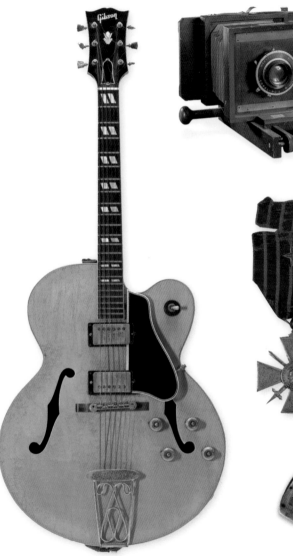

(*top left*) Photographer Rev. Henry Clay Anderson used this large-format camera during the 1960s, documenting African American life in Greenville, Mississippi.

(*left*) The Croix de Guerre, France's highest decoration for bravery, conferred upon Corporal Lawrence McVey of the 369th Infantry—an African American regiment known as the Harlem Hellfighters—during World War I.

(*far left*) Chuck Berry's Gibson guitar, which he named "Maybellene" after his first hit single, released in 1955.

(*below*) An engraved powder horn carried into battle by Prince Simbo, one of thousands of African Americans who fought in the Continental Army during the American Revolution.

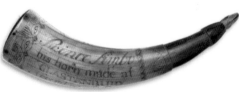

SLAVERY

Between 1619, when the first black servants arrived in Virginia, and 1865, when the Thirteenth Amendment abolishing slavery was passed, millions of African Americans spent their lives in bondage to other Americans, denied all rights to "life, liberty, and the pursuit of happiness."

This Bible likely belonged to Nat Turner of Virginia. It is believed he was carrying it when he was captured on October 30, 1831—two months after leading the bloodiest slave revolt in U.S. history.

(*right*) The first African American to publish a volume of poetry, Phillis Wheatley is depicted on the frontispiece of this 1773 first edition of her work. She wrote the verses while still enslaved.

(*below*) "Freedom papers," like this 1852 Certificate of Freedom once carried by Joseph Trammel of Virginia, were carefully guarded by free African Americans in the South—hence the sturdy handmade metal box.

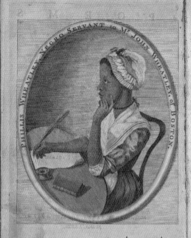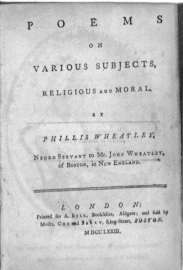

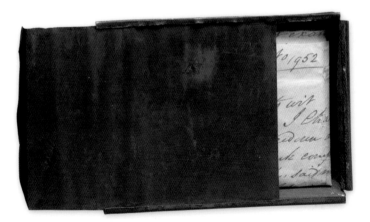

(*below*) Slaveholders in Charleston, South Carolina, who hired out enslaved laborers had to outfit them with identification badges stating their occupation ("Fisher") and the year (here, "1800").

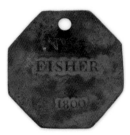

PETER BENTZON

Peter Bentzon (ca. 1783–after 1850) was not only a free man; he was also a silversmith and jeweler who worked in Philadelphia and on the Caribbean island of St. Croix. Bentzon was the first silversmith of African descent working in America to be recognized with his own mark.

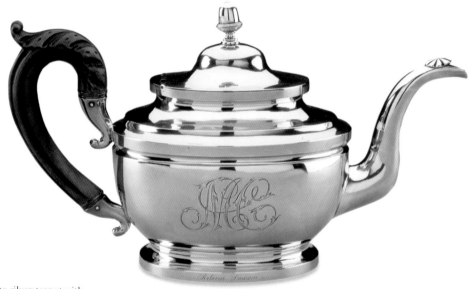

This exquisite silver teapot with an acorn finial, which Bentzon crafted between 1817 and 1829 in Philadelphia, was hand-molded.

DAVE THE POTTER

A rarity in antebellum South Carolina, the master craftsman we know only as Dave the Potter (ca. 1800–ca. 1870) was a literate slave who often signed, dated, and wrote verses on his pots—in an era when slaves were forbidden to read and write.

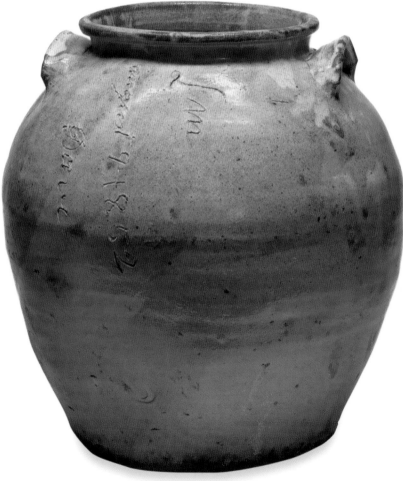

This large stoneware storage jar is signed by its maker, "Dave," and dated 1852.

Born enslaved in Maryland, brave Harriet Tubman (1822–1913) escaped to the North but soon made the first of thirteen trips back to her native state, smuggling scores of family members and friends to freedom. During the Civil War, she led a raid that liberated seven hundred enslaved people.

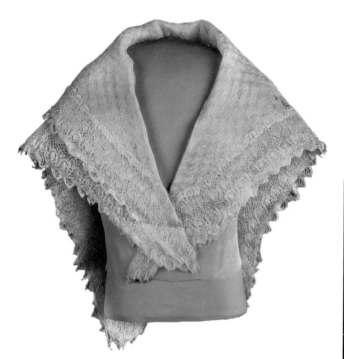

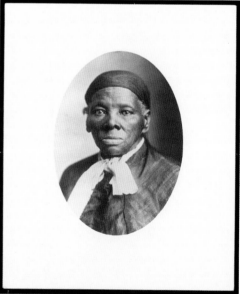

This portrait of Harriet Tubman was taken about 1908 in Auburn, New York, her home for half a century.

Britain's Queen Victoria so admired Harriet Tubman's audacity and dedication that she sent Tubman this silk and lace shawl around 1897.

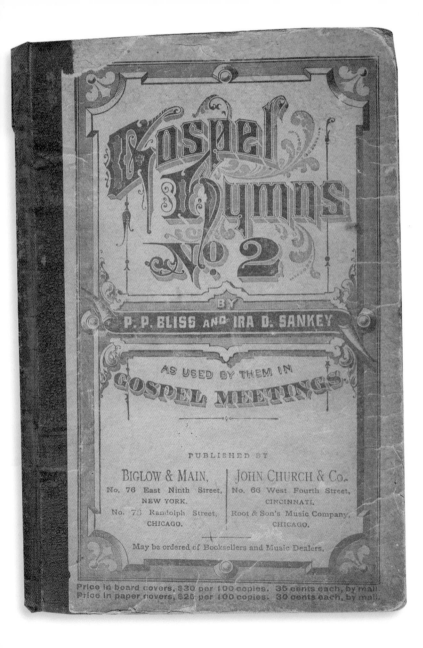

Although she could neither read nor write, Tubman was intensely devout and would have prized this, her personal hymnal.

WILLIAM LLOYD GARRISON

There were few abolitionists more fervent than William Lloyd Garrison (1805–79) of Massachusetts. His weekly newspaper, *The Liberator*, persuaded men and women throughout the North—and beyond the United States—that the time for emancipation was long overdue.

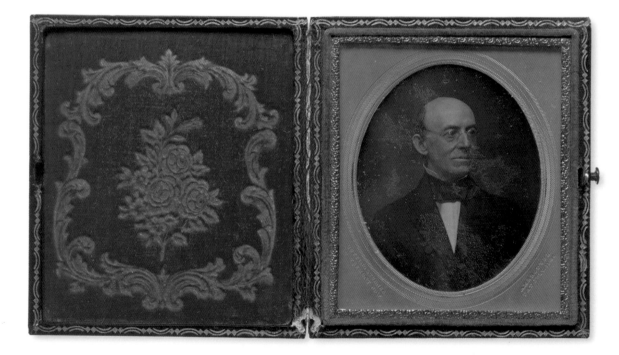

An ambrotype of William Lloyd Garrison made by the Boston photography studio Cutting & Turner around 1860.

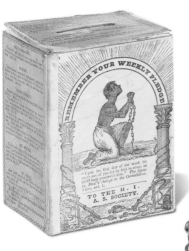

(*far left*) Surrounded by symbols of bondage, an enslaved man is depicted on a coin collection box used by the Garrison family for contributions to the Rhode Island Anti-Slavery Society.

(*near left and below*) This gold pocket watch and watch chain were presented in 1851 to Garrison by George Thompson, a British Member of Parliament and fellow abolitionist.

HEARTFELT WORDS Open the hunter case—an outer cover designed to protect an inscription from damage—and Thompson's dedication to Garrison can be read: "Presented by GEORGE THOMPSON, M.P., on behalf of himself and others to WILLIAM LLOYD GARRISON, intrepid and uncompromising Friend of the Slave: in commemoration of the TWENTIETH ANNIVERSARY OF THE LIBERATOR / Boston / January 1st, 1851."

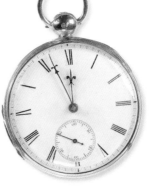

After President Lincoln issued the Emancipation Proclamation in 1863, the federal government began recruiting among free black people and escaped slaves in the North. By the end of the war, almost 200,000 African Americans were serving in the Union Army—nearly 10 percent of its strength.

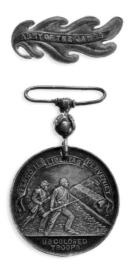

(*above*) The Army of the James Medal was commissioned by General Benjamin F. Butler to honor African American troops who fought with valor at the Battle of New Market Heights, Virginia, on September 29, 1864. The Latin inscription means "Freedom will be theirs by the sword."

(*right*) The citizens of Philadelphia could not fail to miss this eight-by-four-foot bill of June 1863 signed by Frederick Douglass and 53 others, with its ringing appeals to "men of color" to join the fight.

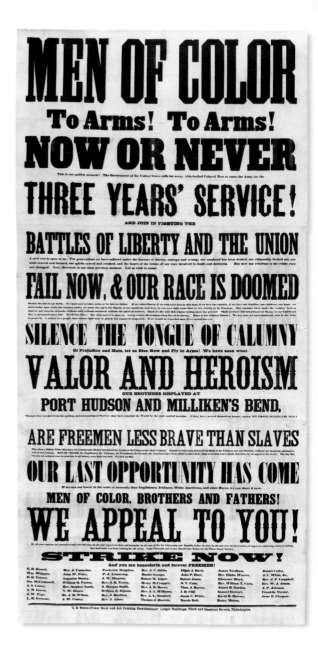

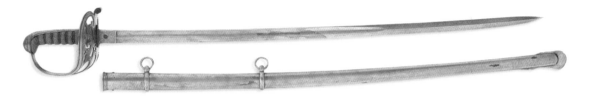

An etched Mameluke sword and scabbard
presented to Captain George Thompson Garrison,
son of William Lloyd Garrison, by the 55th
Massachusetts Volunteer Infantry, the state's
second regiment of African American volunteers.
Its officers were white; its fighting men were black.

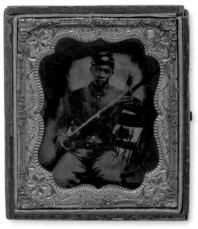

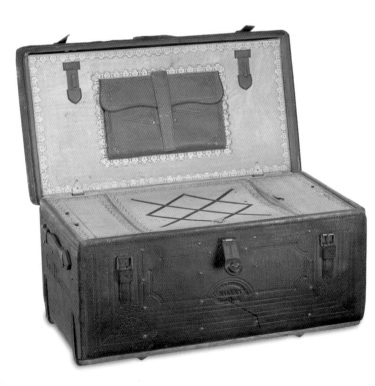

(*above*) An ambrotype of Qualls Tibbs,
a sergeant in the 27th Infantry
Regiment of the United States Colored
Troops. Although wounded, Tibbs
survived the war and lived until 1922.

(*left*) A travel trunk owned by Captain
George Thompson Garrison, who
fought with the 55th Massachusetts.
When Charleston fell in February
1865, he led his soldiers into the
captured city, all of them singing
"John Brown's Body."

EMANCIPATION & RECONSTRUCTION

In 1865, the Civil War ended, Congress passed the Thirteenth Amendment abolishing slavery, and the nation embarked upon the Reconstruction era (ca. 1865–77). African Americans in the South, many of them newly freed slaves, were free to vote, and black people were elected to state and national offices.

(*above*) A campaign button features Senator William B. Nash, a formerly enslaved worker at Hunt's Hotel in Columbia, South Carolina, who served in the South Carolina state senate 1868–77.

(*left*) A walking cane owned by Senator Nash. Its surface is carved with diamonds, fish, snakes, and lizards—symbols of power and protection associated with his African ancestry.

(*right*) A parade in Baltimore celebrates the passing of the Fifteenth Amendment, ratified in February 1870 and stating that the right to vote "shall not be denied or abridged ... on account of race, color, or previous condition of servitude."

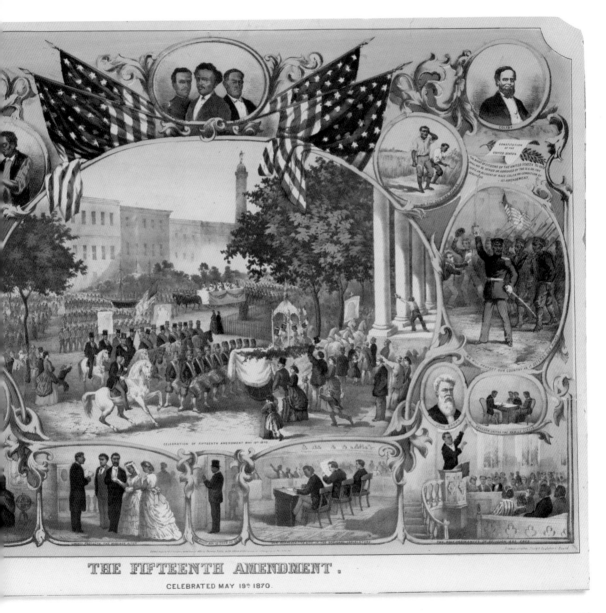

THE FIFTEENTH AMENDMENT.

CELEBRATED MAY 19th 1870.

PORTRAITS

Sometimes these faces return our gaze frankly and openly, and sometimes they look elsewhere. But whether famous or anonymous, the faces of African Americans from the past are as various as the stories that lie half-hidden behind them.

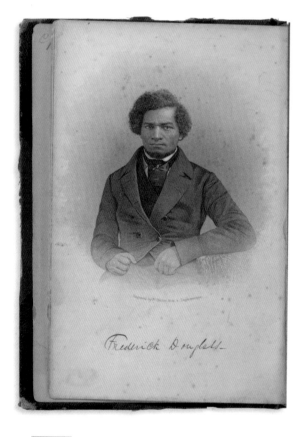

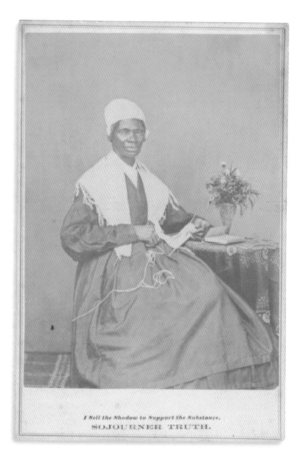

I Sell the Shadow to Support the Substance.
SOJOURNER TRUTH.

(*left*) Sojourner Truth (1864) was an abolitionist and advocate of women's rights.

(*above*) Frederick Douglass (1857) was a great African American writer, orator, and statesman of the 1800s.

(*right*) Pauline Cookman (ca. 1945) served in the Women's Army Corps, a U.S. Army branch created in World War II and made up of segregated units until 1950.

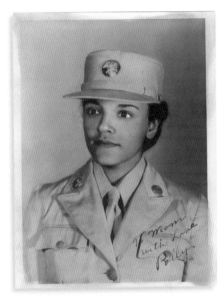

(*below*) This tintype depicts Corporal Prince Shorts (1864–65), who served in the 25th Regiment, U.S. Colored Infantry, during the Civil War.

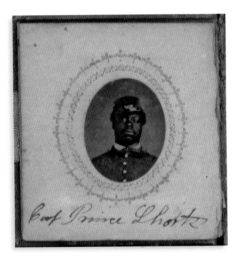

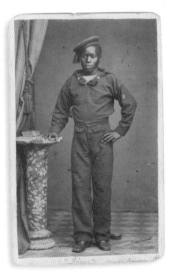

(*right*) From the late 1800s, this *carte de visite*, a small photograph, shows a young African American sailor known only as Jim.

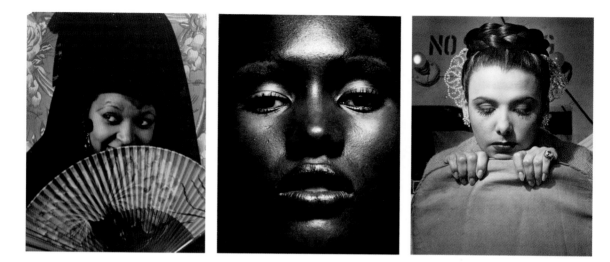

(*above left*) Ethel Waters (1934) plays the gypsy heroine in the opera *Carmen*. The blues and jazz vocalist was also a stage and film actress.

(*above center*) Jamaican-born singer, actress, model, and entertainer Grace Jones poses for a close-up portrait in the 1970s.

(*above right*) Jazz singer and civil rights activist Lena Horne is photographed backstage at Chez Paree, Chicago, in May 1947.

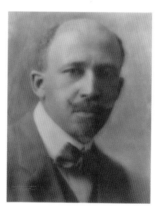
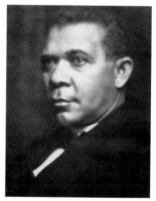

(*near right*) W. E. B. Du Bois, editor, historian, Pan-Africanist, and cofounder of the National Association for the Advancement of Colored People (NAACP) posed for this portrait in 1918.

(*far right*) Booker T. Washington (ca. 1908) founded the pioneering Tuskegee Institute in Alabama in 1881 and served as its first president.

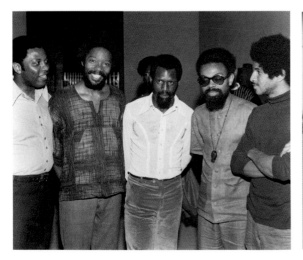

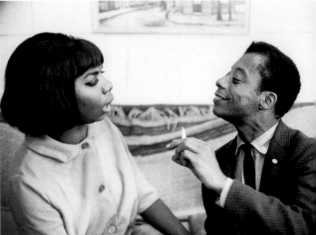

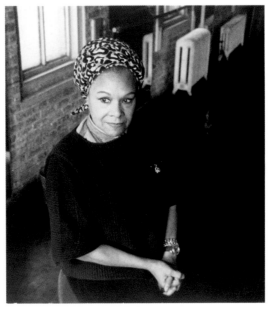

(*above left*) Impresario Woodie King Jr. (*left*) and poet Amiri Baraka (*second from right*) meet with poets David Nelson, Gylan Kain, and Felipe Luciano—the original Last Poets—in 1969.

(*above right*) Singer Nina Simone and writer James Baldwin share ideas in 1965.

(*far left*) A 1940s Brooklyn girl gazes intently at the camera.

(*near left*) Katherine Dunham, pictured here in the 1960s, was the matriarch and queen mother of black dance. She choreographed over ninety dances during her long career.

THE WORMLEY HOTEL

Opened in 1871 by free-born African American entrepreneur James
Wormley, the Wormley Hotel, at 15th and H streets in Washington, D.C.,
was one of the city's most successful hotels, attracting a wealthy and
powerful clientele, including many members of Congress.

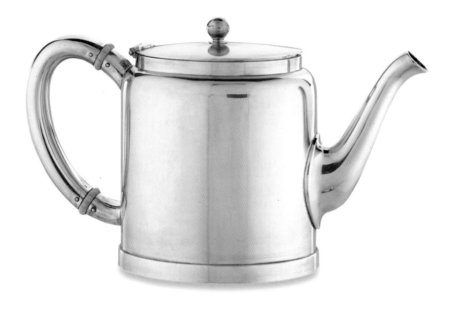

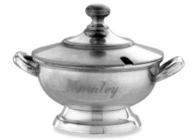 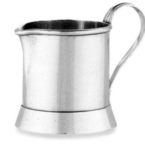

An engraved, silver-plated beverage
service from the Wormley Hotel.
At left is the sugar bowl and
creamer; above is the teapot.

HOPE SCHOOL

The Hope School in Pomaria, Newberry County, South Carolina, opened in 1925, thanks in part to a grant from the Julius Rosenwald Fund. The Fund assisted thousands of black communities throughout the South who raised matching funds to provide their schools with teachers, supplies, and students.

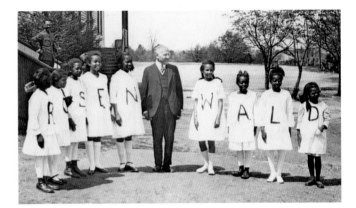

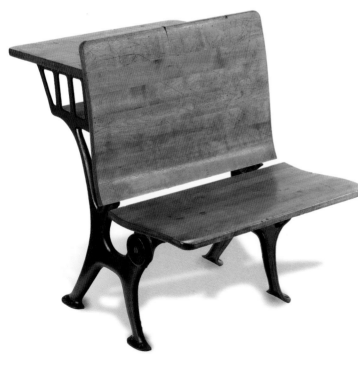

(*above*) Philanthropist Julius Rosenwald, president of Sears, Roebuck, poses with African American students at one of the schools he helped fund.

(*left*) A desk from the Hope School, a Rosenwald school that housed two classrooms. It closed in 1954 when new public schools were established in Newberry County to provide so-called equal, but still separate, facilities for white children and African American children.

PULLMAN PORTERS

In the early twentieth century, a job as a Pullman porter meant status for African American men. Although catering to passenger needs in the famous sleeping cars could be menial, the wages were good, and the Brotherhood of Sleeping Car Porters was a powerful and protective black labor union.

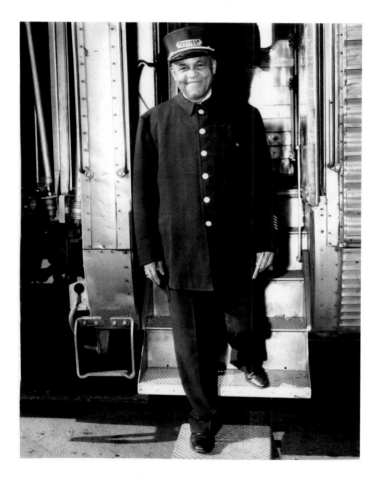

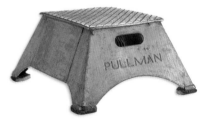

(*left*) Pullman porters greeted train passengers for decades: James Bryant, seen standing here on the steps of a Pullman sleeper, worked at the Pullman Company from 1928 to 1973.

(*below*) Porters would place step stools such as this one at each stop to assist passengers climbing down from the cars.

(*top left*) Wearing a uniform cap such as this one, a Pullman porter would use a hole punch to cancel tickets after passengers had boarded the train.

(*above*) Set on a Pullman company towel are a Pullman clothes hanger, a brush used to remove coal cinders from passengers' coats, and a shoehorn. Porters also shined shoes left in lockers outside sleeping compartments.

(*left*) A Pullman porter's wool uniform coat, donned whenever the train stopped to disembark and board passengers.

SEGREGATED RAILCAR

Built by the Pullman Palace Car Company and owned and operated by Southern Railway, car no. 1200 ran as a long-distance passenger coach between Washington, D.C., and New Orleans in the 1940s and 1950s. Operating separate passenger cars for blacks and whites was expensive, so railcars such as this one were reconfigured to create partitioned "white" and "colored" sections to oblige Jim Crow segregation in the South. African Americans repeatedly challenged state-mandated separate accommodations in the nineteenth and twentieth centuries, both before and after the Supreme Court upheld the "separate but equal" doctrine in *Plessy v. Ferguson* (1896). A string of legal challenges brought before the Interstate Commerce Commission and the Supreme Court between 1940 and 1960 paved the way for the end of segregated interstate trains and buses.

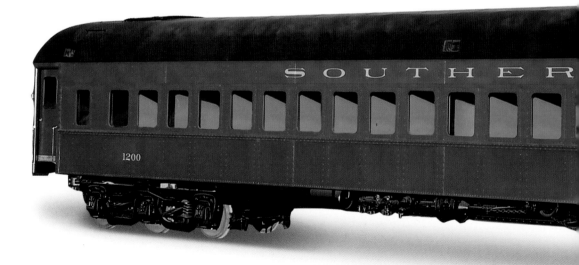

THE MUSEUM BUILT AROUND A TRAIN

There is no easy way to get a railroad car into a building not constructed as a train station. But the genuine segregated Southern Railway car promised to be a worthy addition to the "Defending Freedom, Defining Freedom: Era of Segregation" exhibition. So once the building foundation was secure, Museum officials simply had the 77-ton carriage hoisted into place by cranes before the walls even went up.

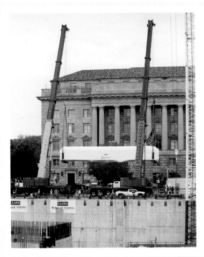

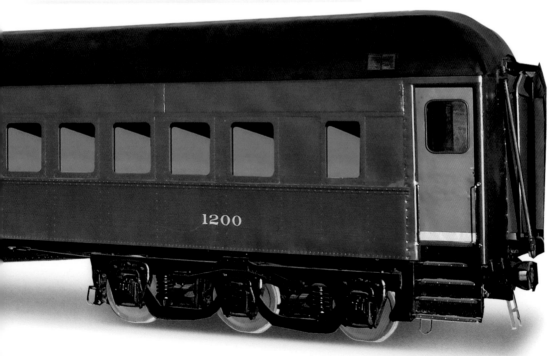

1200

TUSKEGEE AIRMEN

African American fighter pilots known as the Tuskegee Airmen
distinguished themselves overseas during World War II, flying thousands
of sorties and destroying scores of enemy aircraft, locomotives, and vessels.

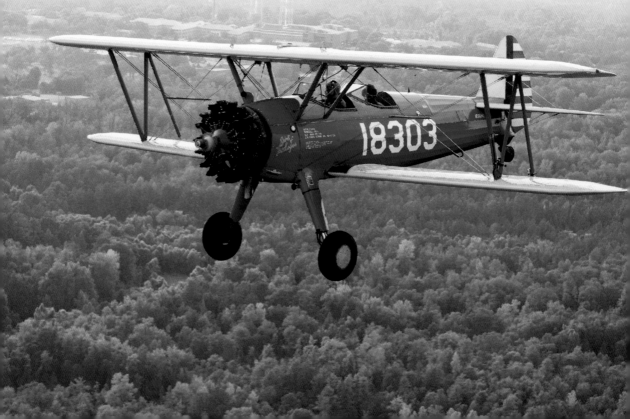

(*above*) A 1943 U.S. Treasury war bonds poster encouraging investment in the war effort featured an image of Tuskegee Airman Robert W. Diez.

(*top right*) This flight jacket was issued in 1943 to Lieutenant Woodrow W. Crockett, an original Tuskegee Airman. He subsequently flew 145 combat missions over Italy.

(*left*) A restored airplane, used at Moton Field in Tuskegee, Alabama, to train prospective African American pilots in World War II, takes to the skies again.

HIGHEST HONOR

The Tuskegee Airmen Congressional Gold Medal, presented to surviving members by President George W. Bush in 2007, recognizes their "unique military record that inspired revolutionary reform in the Armed Forces."

MARIAN ANDERSON

Despite being a top concert box-office draw, contralto Marian Anderson was barred by the Daughters of the American Revolution (DAR) from singing in DAR Constitution Hall because of her race. The federal government then invited her to perform on the steps of the Lincoln Memorial. Nearly 75,000 people congregated there on Easter Sunday, April 9, 1939, to hear her.

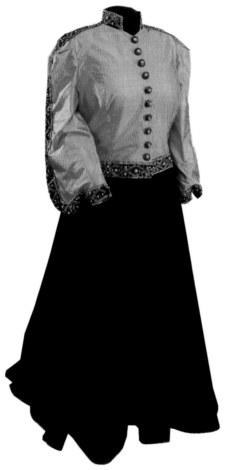

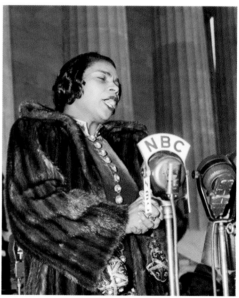

(*above*) It was not only the crowds on the National Mall in Washington, D.C., who heard Marian Anderson's voice, but also the nation, thanks to NBC Radio.

(*left*) Marian Anderson wore this ensemble (modified in 1993) when she gave her famous concert on the steps of the Lincoln Memorial.

DOUBLE V CAMPAIGN

Only weeks after the United States entered World War II, an African American newspaper, the *Pittsburgh Courier*, called for not one victory but two—one over fascism abroad, the other over racism at home. Throughout the black community, the "Double V" motif quickly appeared in everything from gardens to fashion.

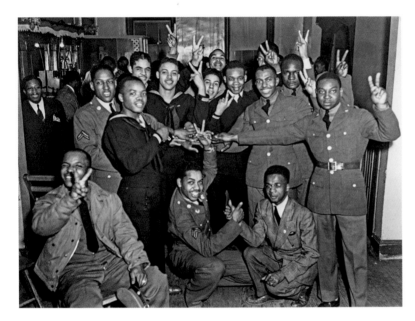

(*left*) One victory down, another still to come: African American servicemen in Brooklyn flash the V for Victory sign in 1947.

(*below*) A red, white, and blue handkerchief promotes the Double V campaign. African Americans needed no reminding that they, too, were fighting a two-front war.

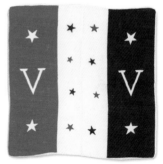

CIVIL RIGHTS

The decade from 1955 to 1965, from the Montgomery Bus Boycott to the passing of the Voting Rights Act, were years of revolution—years that saw African Americans finally granted the same rights, protections, and privileges that their fellow citizens had long enjoyed.

LALLIE·KEMP·CHARITY·HOSPITAL
CLINIC & CLINIC HOURS
Monday
OB (COLORED) 8:00 A.M. TO 11:00 A.M.
GYN (COLORED) 1:00 P.M. TO 4:00 P.M.
Tuesday
MEDICINE (WHITE) 8:00 A.M. TO 12:00 NOON
PEADIATRICS (WHITE) 1:00 P.M. TO 3:00 P.M.
Wednesday
OB (WHITE) 8:00 A.M. TO 11:00 A.M.
GYN (WHITE) 1:00 P.M. TO 4:00 P.M.
DENTAL (WHITE) 8:00 A.M. TO 12:00 NOON
Thursday
SURGERY (WHITE) 8:00 A.M. TO 12:00 NOON
SURGERY (COLORED) 1:00 P.M. TO 4:00 P.M.
Friday
MEDICINE (COLORED) 8:00 TO 12:00 NOON
PEADIATRICS (COLORED) 1:00 P.M. TO 3:00 P.M
DENTAL (COLORED) 8:00 A.M. TO 12:00 NOON
Saturday
ORTHOPEDIC (WHITE & COLORED) 8:00 A.M. TO 11:00 A.M.
(ONLY EMERGENCIES SEEN AFTER CLINIC HOURS & ON SUNDAYS)

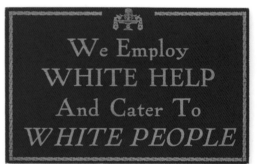

We Employ
WHITE HELP
And Cater To
WHITE PEOPLE

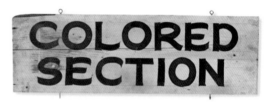

COLORED
SECTION

(*above top*) A restaurant sign, probably from Oregon and dating from before World War II, shows that racism was not limited to the South.

(*above*) Probably painted before 1950, this sign demarcated seating in a railroad carriage.

(*left*) As noted in this sign, dating from before 1965, a clinic in rural Louisiana staggered its hours so that white patients and "colored" ones never had to cross paths.

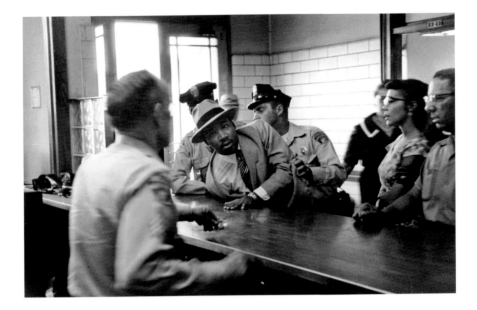

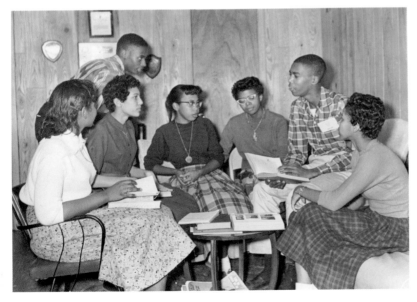

(*above*) While attending the 1958 trial of his fellow activist, Ralph Abernathy, Martin Luther King Jr. was arrested for loitering outside a courtroom in Montgomery, Alabama.

(*left*) Seven of the Little Rock Nine consult in the house of Daisy Bates, a local NAACP leader, in March 1958. They were the first African American students to be integrated into all-white Little Rock Central High—after the intervention of the U.S. Army.

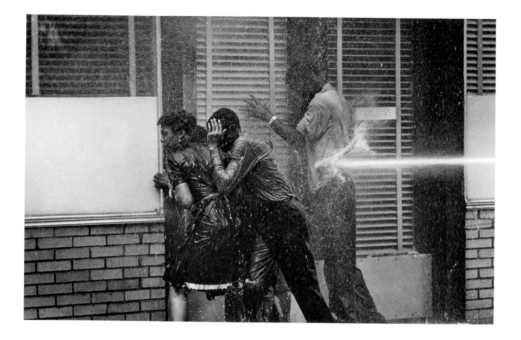

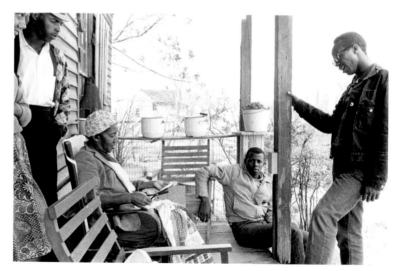

(*above*) In 1963 during the Children's Crusade, young civil rights demonstrators in Birmingham, Alabama, who eluded police attack dogs found themselves buffeted by high-pressure fire hoses.

(*right*) Two members of the Student Non-Violent Coordinating Committee (SNCC), Field Secretary Charles Sherrod and Randy Battle, meet with supporters in rural Georgia in 1963.

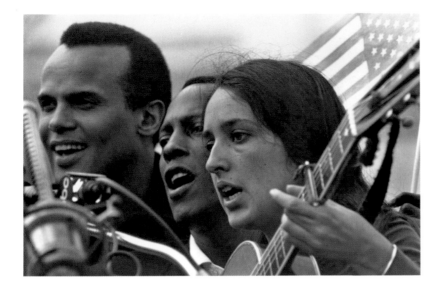

(*left*) Singers Harry Belafonte, Leon Bibb, and Joan Baez entertain participants during the voting rights march from Selma to Montgomery, Alabama, in 1965.

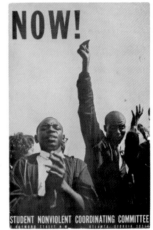

(*above*) A poster released by SNCC in 1965 echoed the Civil Rights Movement cry: If not now, then when?

(*left*) On the first attempt to complete the Selma to Montgomery March, peaceful demonstrators received a "two-minute warning" before being violently attacked by police. John Lewis (in light colored coat) suffered injuries. On his right is Hosea Williams.

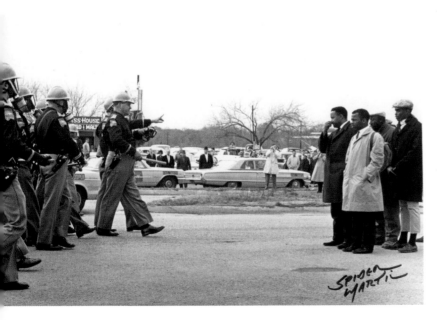

37

BUTTONS

A simple way to say a lot, buttons and badges can be flagrant or discreet depending on circumstances and intentions. Below is a sampling of a century's worth of buttons worn by African Americans, friends of civil rights, and others hoping to make a statement with impact.

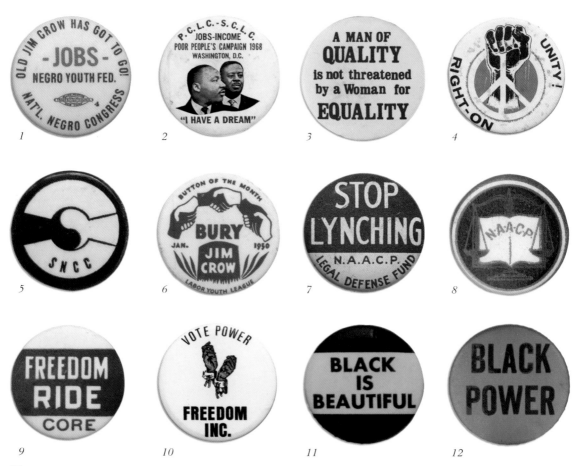

1. OLD JIM CROW HAS GOT TO GO! -JOBS- NEGRO YOUTH FED. NATL. NEGRO CONGRESS

2. P.C.L.C.-S.C.L.C. JOBS-INCOME POOR PEOPLE'S CAMPAIGN 1968 WASHINGTON, D.C. "I HAVE A DREAM"

3. A MAN OF QUALITY is not threatened by a Woman for EQUALITY

4. UNITY! RIGHT-ON

5. SNCC

6. BUTTON OF THE MONTH BURY JIM CROW JAN. 1950 LABOR YOUTH LEAGUE

7. STOP LYNCHING N.A.A.C.P. LEGAL DEFENSE FUND

8. N.A.A.C.P.

9. FREEDOM RIDE CORE

10. VOTE POWER FREEDOM INC.

11. BLACK IS BEAUTIFUL

12. BLACK POWER

13

14

15

16

17

18

19

20

21

22

23

24

1. "Old Jim Crow Has Got to Go!": National Negro Congress, ca. 1941
2. Poor People's Campaign, with Martin Luther King Jr. and Ralph Abernathy, 1968
3. Women's equality badge, 1980s
4. Black power badge, ca. 1970
5. Clasped hands: Student Non-Violent Coordinating Committee, 1960s
6. Interlocking hands ("Bury Jim Crow"), Labor Youth League, 1950
7. "Stop Lynching," NAACP Legal Defense Fund, 1940s
8. Scales of justice, NAACP, 1909–19
9. Freedom Rider's badge, Congress of Racial Equality, 1961
10. Shackled hands, Freedom, Inc., 1960s
11. "Black Is Beautiful," 1960s–70s
12. "Black Power," 1970s
13. "All Power to the People," Black Panther Party, late 1960s
14. Senator Barbara Jordan, 1992 keynote speaker, Democratic National Convention
15. Harold Washington mayoral campaign, Chicago, 1980s
16. Dick Gregory presidential campaign, 1968
17. Jesse Jackson presidential campaign, 1984
18. Julian Bond congressional campaign, 1986
19. Shirley Chisholm presidential campaign, 1972
20. Equal Rights Amendment, 1982
21. Million Man March, Washington, D.C., October 19, 1995
22. Million Woman March, Philadelphia, October 25, 1997
23. Al Sharpton presidential campaign, 2004
24. "Hope Wins," 2008

SPORTS

Even when integration was still unthinkable, sports gave African Americans the chance to beat bigotry and discrimination. Black heroes emerged from boxing, football, and other sporting arenas, winning the races, throwing the punches, and making the touchdowns that gave black people increased hope and self-worth—and role models they could emulate.

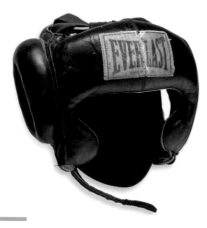

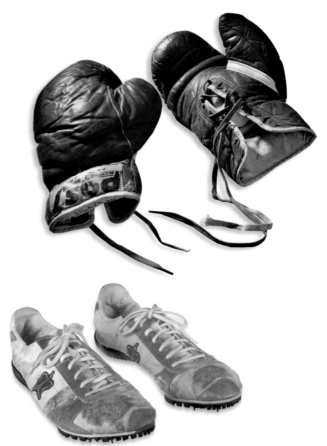

(*above*) Everlast headgear used by Muhammad Ali in 1973 at The Champ's favorite training venue, Dundee's 5th St. Gym in Miami, where he launched his professional career.

(*above right*) Training gloves worn by Cassius Clay, later Muhammad Ali, in 1960, the year he won the light heavyweight gold medal at the Rome Olympics.

(*right*) Carl Lewis wore these custom-made track shoes during the 1990s—when he set world records in the 100-meter dash.

(*center right*) A baseball signed by members of the New York Giants after they won the 1954 World Series. Among them was Willie Mays, whose over-the-shoulder running catch in deep center field—"The Catch"—is the most famous moment of that series.

(*below right*) Tennis star Althea Gibson wore this white blazer in 1957 when she was a member of the U.S. Wightman Cup team. The first African American to break the color barrier in tennis, she would go on to win Wimbledon later that year.

(*below*) The front and back of the Olympic gold medals awarded to Carl Lewis for the men's long jump in the 1984 Los Angeles games (*left*)—and twelve years later at the 1996 Atlanta games (*right*).

(*right*) An autographed Ohio State Buckeyes football helmet worn in the early 1970s by Archie Griffin, the only two-time winner of the Heisman Trophy.

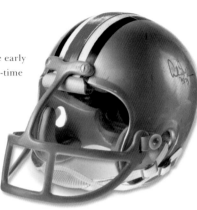

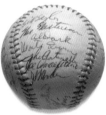

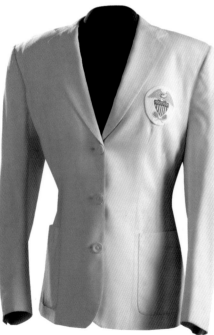

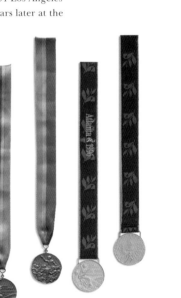

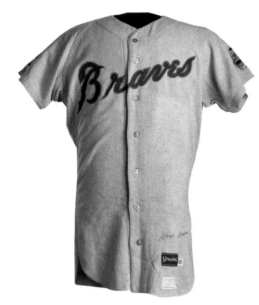

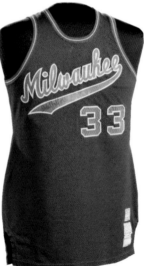

(*above*) An Atlanta Braves road jersey worn by Hank Aaron in the late 1960s, when "The Hammer" was well on his way to the top of the all-time home run leader list, which he headed for thirty-three years.

(*far right*) The tracksuit worn by Tommie Smith when, receiving the gold medal for the 200-meter dash at the 1968 Mexico City Olympics, he stood on the podium and gave the black power salute.

(*right*) A Milwaukee Bucks basketball jersey worn in the early 1970s by Kareem Abdul-Jabbar, the NBA's all-time leading scorer.

(*right*) A Brooklyn Nets basketball jersey worn by Jason Collins, the first openly gay athlete to play in any of the four major North American professional leagues. All of Collins's teammates signed the back of his jersey (*far right*) when he retired in 2014—a tradition but also a sign of acceptance among his peers.

(*bottom left*) Wearing number 32, Cleveland Browns fullback Jim Brown, one of the greatest football players in NFL history, spent nine years (1957–65) breaking all previous rushing records.

(*bottom right*) The jersey worn by goalie Briana Scurry during the game in which the American women's soccer team won the 1999 Women's World Cup.

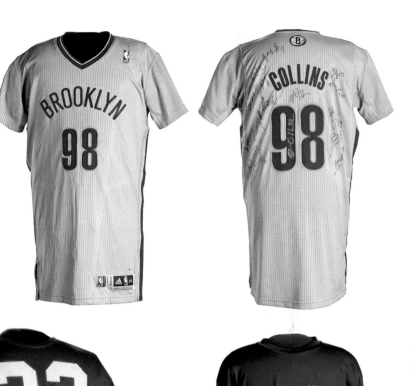

HATS BY MAE REEVES

One of the first African American female business owners in downtown Philadelphia, Mae Reeves provided her clients with an essential item of fashion in the 1940s and 1950s: a hat. Ella Fitzgerald, Lena Horne, and Marian Anderson all purchased hats from Mae's Millinery Shop.

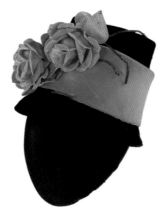

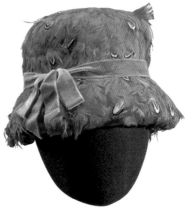

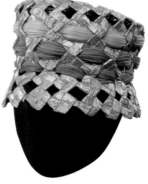

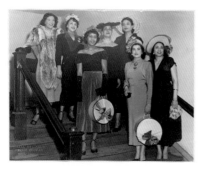

PROPER TOPPER In a photograph taken around 1950, Mae Reeves stands on the bottom step on the right—in a white hat—with hat-wearing companions.

(*top left*) This black velvet beehive hat is trimmed with pink velvet and artificial roses.

(*above*) A red-feather "lampshade" hat is accented with brown pheasant plumage.

(*left*) A green lampshade hat features diamond-shaped knots of light-green raffia.

GOWNS BY ANN LOWE

Many a socialite visited Ann Lowe's Gowns, a salon on Manhattan's Lexington Avenue, in the 1950s. The daughter and granddaughter of African American seamstresses, Lowe designed the wedding dress worn by Jacqueline Bouvier when she married John F. Kennedy in 1953.

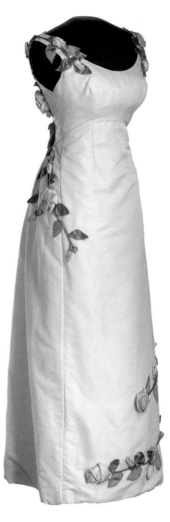

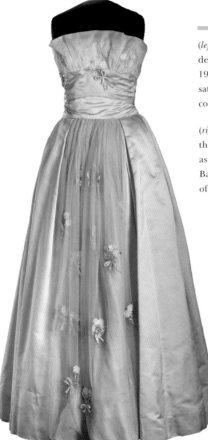

(*left*) A strapless ball gown designed by Lowe in 1959 is made of pale-pink satin, with pink organza covering the décolletage.

(*right*) Designed in 1966, this dress is referred to as the "American Beauty Ball Gown," for the variety of roses adorning it.

A TRADITION OF QUILTING

Many patches make masterpieces: African American women have transformed quilting from a labor of dire necessity—using scraps of fabric, worn-out clothing, even empty feed sacks—into an abstract and improvisational art with great storytelling power.

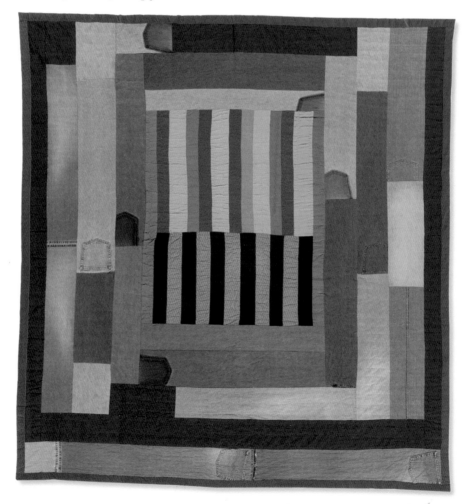

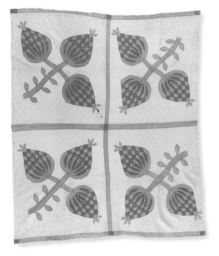

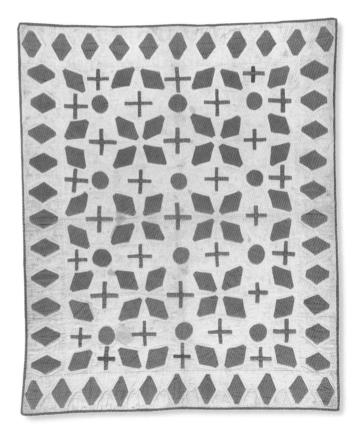

(*above*) This quilt with a pineapple motif, symbolizing home and family, was made by Lydia Hardiman as a wedding gift for her daughter Lucy Hardiman Roundtree in 1885.

(*right*) A crib quilt, created around 1850, features crosses, coffins, and suns and was perhaps made as a memorial for a child who died or to protect a sleeping child.

(*opposite*) "Silo," a strip-style quilt made in 2007 by Mensie Lee Pettway of Gee's Bend, Alabama, reflects the quilting traditions of three generations of her family.

JAZZ AND BLUES

African American rhythms lie at the root of popular music. The blues that
grew out of field songs gave rise to jazz, which during its twentieth-century
heyday was given its finest expression by black singers and musicians.
While jazz was crowned as America's greatest contribution to world music,
the blues resurfaced in rhythm and blues—the parent of rock 'n' roll.

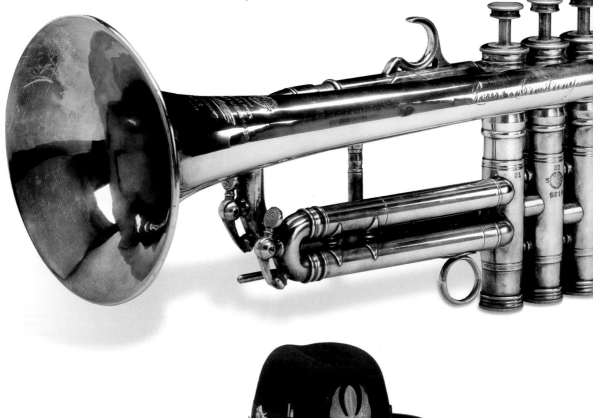

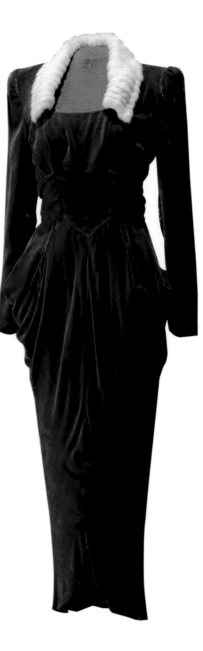

(*above*) A brass-and-gold Selmer trumpet made in Paris after World War II for Louis Armstrong, one of the most influential musicians in the history of jazz.

(*right*) A velvet dress worn by Lena Horne in the 1943 film *Stormy Weather*. The actress, dancer, and singer fought discrimination and refused to perform to segregated audiences.

(*left*) Singer and guitarist Bo Diddley wore this hat during the last fifteen years of his rhythm-and-blues career. The artist who "gave rock its beat" decorated his headgear with a Smokey the Bear pin, a gold alligator pin, and a large silver medallion bearing the name "Bo," designed by Diddley himself.

ROCK 'N' ROLL TO SOUL

In the 1950s, thanks in part to Chuck Berry's blazing guitar, rhythm and blues burst through the color barrier and, in the form of rock 'n' roll, took the world by storm. When rhythm and blues fused with the black gospel singing tradition, soul music emerged. As pop music continues to evolve, African American blues remains a common root.

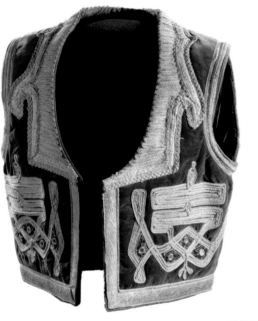

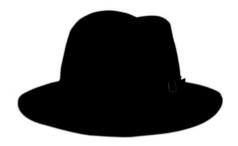

(*above*) A black fedora worn by Michael Jackson during his 1984 Victory Tour and caught by a fan during a performance at Giants Stadium.

(*top left*) This quilted Afghan-style vest is one of many once owned by Jimi Hendrix, one of the most inventive, influential, and flamboyant electric guitarists in the history of rock music.

(*left*) A tambourine used on stage during one of seven London performances during Prince's 1990 Nude Tour.

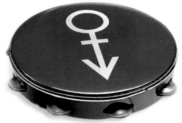

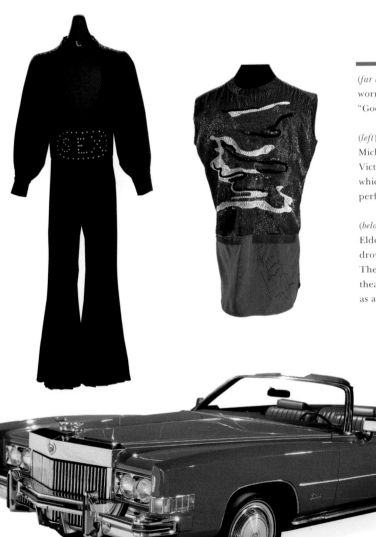

(*far left*) A provocative jumpsuit worn by James Brown, the "Godfather of Soul."

(*left*) A sleeveless shirt worn by Michael Jackson during the 1984 Victory Tour, the only tour in which all six Jackson brothers performed together.

(*below*) A 1973 red Cadillac Eldorado that Chuck Berry once drove onto the stage of the Fox Theater in St. Louis, the same theater that had turned him away as a child because of his race.

THE MOTHERSHIP

Both a zany stage prop and the centerpiece of P-Funk mythology, George Clinton's Mothership symbolized the journey to transcendence induced in both performers and audience during Parliament-Funkadelic's dazzling, storytelling concerts.

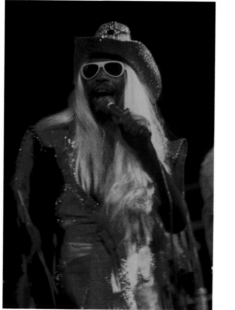

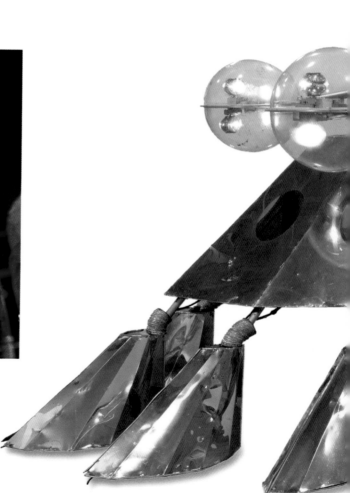

George Clinton was the creative genius behind radical funk—and an important influence on today's rap and hip-hop.

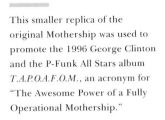

This smaller replica of the original Mothership was used to promote the 1996 George Clinton and the P-Funk All Stars album *T.A.P.O.A.F.O.M.*, an acronym for "The Awesome Power of a Fully Operational Mothership."

HIP-HOP AND RAP

In recent years African American musical styles and rhythms have again reinvigorated popular music. The core elements of hip-hop culture—DJing, emceeing (or rapping), breakdancing, and graffiti—emanated from the inner cities in the 1970s and found their musical expression through breakbeats, couplet rhymes, intricate vocal delivery, and social commentary.

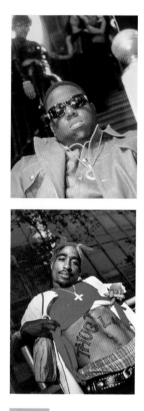

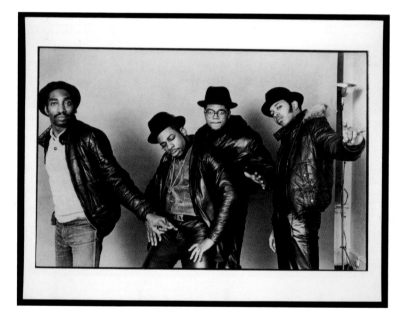

(above) Rap icons Notorious B.I.G. (above, top) and Tupac Shakur (above, bottom) were both noted for their narrative styles and storytelling techniques.

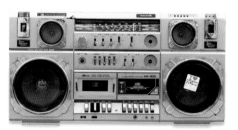

(right) A boom box used by Public Enemy, self-styled "prophets of rage" and one of the most groundbreaking rap groups to emerge from the 1980s golden age of hip-hop.

(top left) With coproducer Larry Smith (left), the group Run-DMC—Jam Master Jay, DMC, and Reverend Run—became famous for rapping over rock beats.

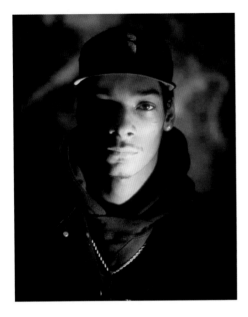

(*left*) Snoop Dogg delivered a more laid-back version of the gangsta rap of his mentor Dr. Dre in the 1990s.

(*below left*) The Fugees (Wyclef Jean, Lauryn Hill, and Pras Michel) achieved popular success in the 1990s, many of their raps being rooted in reggae.

(*below*) Mary J. Blige, seen here in 1992, would two years later release the album *My Life*, revolutionizing pop music by marrying hip-hop with rhythm and blues and soul.

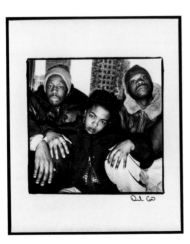

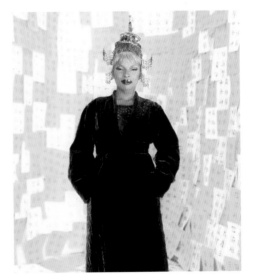

PERFORMANCE

African American artists and performers developed
various strategies to overcome the limits that
white society placed on their creative freedom,
opportunities, and identities. In 1959,
A Raisin in the Sun, by twenty-nine-year-old
Lorraine Hansberry, became the
first all-black Broadway play to
win a New York Drama
Critics Award. Since then,
four African Americans
have won the Pulitzer Prize
for Drama.

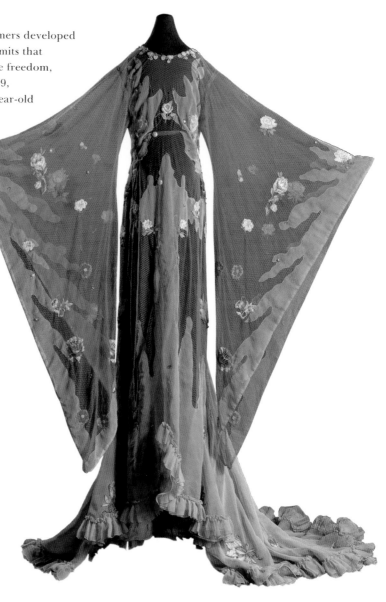

The costume designed by Geoffrey
Holder and worn by Dee Dee
Bridgewater in her Tony Award–
winning performance as Glinda,
the Good Witch, in the smash
1975 Broadway hit *The Wiz:
The Supersoul Musical "Wonderful
Wizard of Oz."*

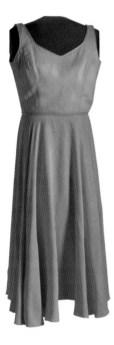
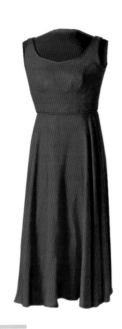

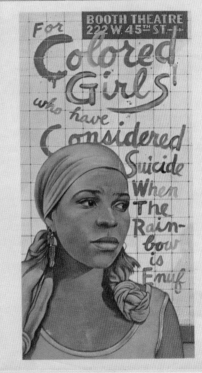

PLAYBILL
THE BOOTH THEATRE

(*above*) Trazana Beverley wore this sleeveless red dress when she portrayed the Lady in Red in Ntozake Shange's choreopoem *for colored girls who have considered suicide/when the rainbow is enuf*. Shange herself wore the orange dress when she played the Lady in Orange on the Broadway opening night in 1976.

(*right*) A playbill from a November 1977 Broadway performance at the Booth Theater.

Founded in 1958, the Alvin Ailey American Dance Theater (AAADT) is now a world-famous exponent of modern dance. Its repertoire spans more than two hundred works, nearly half choreographed by its founder, Alvin Ailey, who was posthumously awarded a Presidential Medal of Freedom in 2014.

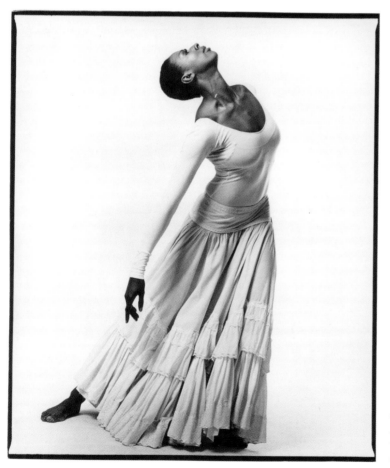

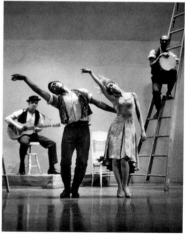

(*below*) Alvin Ailey and Carmen De Lavallade perform *Roots of the Blues*, in Ailey's 1961 paean to African American musical traditions.

(*left*) Judith Jamison in her most famous solo performance, 1971's *Cry*, choreographed by Alvin Ailey and dedicated to "black women everywhere, especially our mothers."

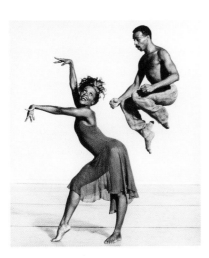

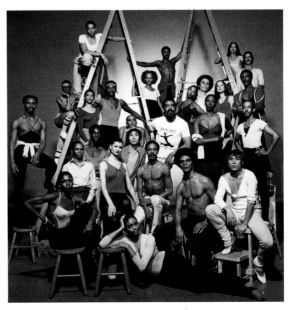

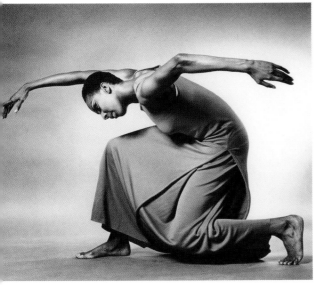

(*top left*) A leaping Carl Bailey and
Renee Robinson dance in a 1989
performance of choreographer Donald
McKayle's *Rainbow 'Round My Shoulder*,
set on a chain gang in the South.

(*above*) Recognition of the brilliant
artistic achievements of Alvin Ailey
(*center*) and the members of AAADT
was widespread by the time of this
1978 photograph.

(*left*) Judith Jamison in Ailey's critically
acclaimed *Revelations*, a 1967 suite that
dramatized the African American story
from enslavement to freedom.

ART

Like other American artists, black artists in the nineteenth century worked in the European tradition. After World War I, however, some African American painters and sculptors explored their cultural roots and embraced more abstract forms and designs.

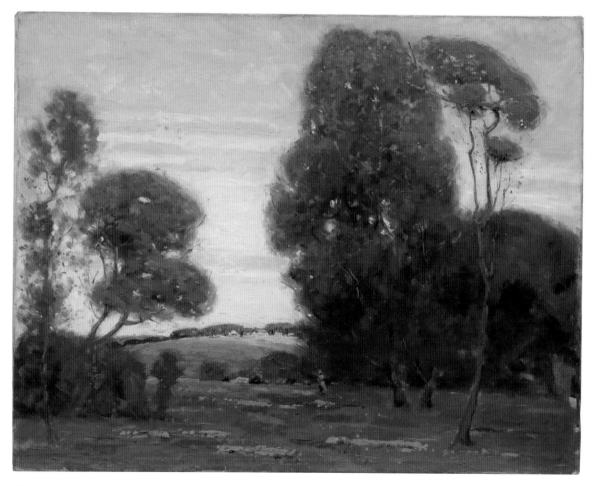

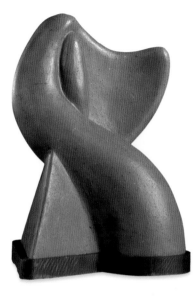

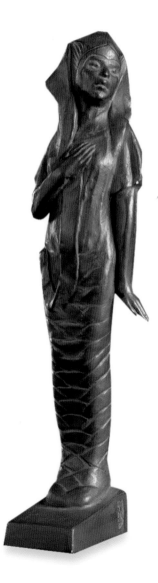

(*above*) *Dancer* (1938–1940) was sculpted by Sargent Claude Johnson, the first African American artist on the West Coast to win national recognition.

(*right*) Meta Vaux Warrick Fuller's *Ethiopia* (ca. 1921) symbolizes Africans shedding the bonds of enslavement and reawakening to their ancient heritage.

(*opposite*) William A. Harper, who studied in Paris as well as Chicago, painted this untitled French rural scene in 1905.

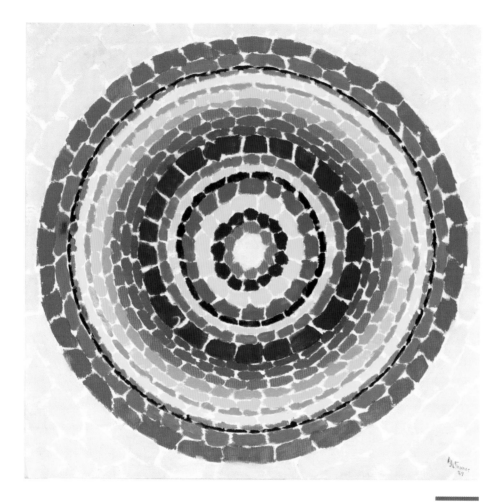

Spring—Delightful Flower Bed was
painted in 1967 by Alma Thomas,
a lifelong artist who was not
widely recognized until she
was in her seventies.

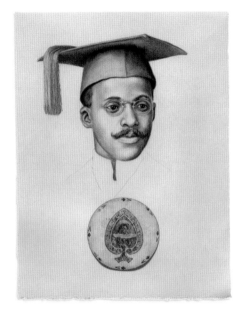

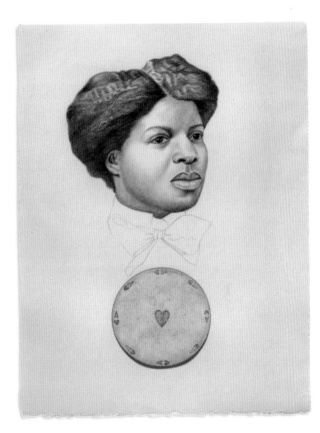

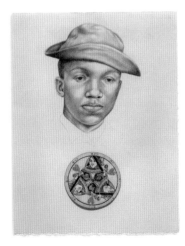

Whitfield Lovell's *The Card Series II: The Rounds* (2006–2007) consists of charcoal portraits of anonymous African American men and women, their faces taken from vintage photographs and matched with round playing cards—inviting the viewer to make links between the two elements.

443 418 1142

Published by Smithsonian Books
Director: Carolyn Gleason
Managing Editor: Christina Wiginton
Editorial Assistant: Jaime Schwender

National Museum of African American History and Culture
Director: Lonnie G. Bunch III
Deputy Director and General Editor: Kinshasha Holman Conwill
Publications Team: Michèle Gates Moresi, Laura Coyle, Douglas Remley, Jacquelyn Serwer, and Emily Houf
Museum Photographer: Alexander Jamison

Produced by Potomac Global Media in collaboration with Toucan Books, Ltd.
Kevin Mulroy, Publisher, Potomac Global Media, LLC
Ellen Dupont, Editorial Director, Toucan Books Ltd.
Mark Collins Jenkins, Text and Captions
La Tricia Watford, Design

Library of Congress Cataloging-in-Publication Data is available upon request.

Half title: Crowds reach back to the Washington Monument at the 1963 March on Washington for Jobs and Freedom.
Title: *Reflection Pool* (1974), tapestry designed by Romare Bearden and created by Gloria F. Ross.

Manufactured in China, not at government expense
20 19 18 17 16 6 5 4 3 2

Picture Credits
Key: top (*t*), bottom (*b*), left (*l*), right (*r*), center (*c*)

National Museum of African American History and Culture: 1: 2012.107.5, © Bruce Davidson/Magnum Photos **2:** 2015.255, Gift of Richard and Laura Parsons, © Romare Bearden Foundation/Licensed by VAGA **5:** Alan Karchmer/NMAAHC **7:** *l* 2011.137.2, Donation of Charles E. Berry; *tr* 2007.1.37.1; *cr* 2011.108.9.1, Gift of Gina R. McVey, grand daughter; *br* 2009.14.1 **8:** 2011.28, Gift of Maurice A. Person and Noah and Brooke Porter **9:** *bl* 2014.25, Gift of Elaine E. Thompson in memory of Joseph Trammell on behalf of his direct descendants; *tr* 2012.46.46; *br* 2010.27.1 **10:** 2010.14, Image courtesy Carnegie Museum of Art, Pittsburgh. Photo: Tom Little **11:** 2011.69 **12:** *l* 2009.50.39, Gift of Charles L. Blockson; *r* 2009.50.25, Gift of Charles L. Blockson **13:** 2009.50.25, Gift of Charles L. Blockson **14:** 2014.115.10, Gift of the Garrison Family in memory of George Thompson Garrison **15:** *c/bl/br* 2014.115.6.1, Gift of the Garrison Family in memory of George Thompson Garrison; *tl* 2014.155.9, Gift of the Garrison Family in memory of George Thompson Garrison **16:** *l* 2012.37, Gift of the Family of Irving and Estelle Liss; *r* 2012.133 **17:** *t* 2014.115.1.1ab, Gift of the Garrison Family in memory of George Thompson Garrison; *b* 2010.24a-d; *r* 2011.4.2 **18:** *r* 2013.168.2, Gift of the Family of William Beverly Nash; *r* 2013.168.1, Gift of the Family of William Beverly Nash **19:** 2010.45.11 **20:** *l* 2013.207.1; *r* 2011.43.2, Gift of Elizabeth Cassell **21:** *l* 2014.88f, Gift of Aneita Gates, on behalf of her son, Kameron Gates, and all the Descendants of Captain William A. Prickitt; *br* 2011.155.55; *tr* 2011.155.135 **22:** *tl* 2010.42.4; *tc* 2014.157.10, Gift of Anthony Barboza, © Anthony Barboza; *tr* 2009.24.9, © Wayne Miller/Magnum Photos; *bl* 2009.37.3, © Tuskegee Archives; *br* 2009.37.2, © Tuskegee Archives **23:** *tl* 2012.21.5.1, © Monroe S. Frederick II; *tr* 2011.132.5.5, Photograph © Bernard Gotfryd; *bl* 2010.74.19, Gift of Joe Schwartz and Family, © Joe Schwartz; *br* 2013.66.3, Gift of Nell Draper-Winston, © The Louis Draper Archive **24:** *t* 2013.104.1, Gift of Charles Thomas Lewis; *bl* 2013.104.2ab, Gift of Charles Thomas Lewis; *br* 2013.104.3, Gift of Charles Thomas Lewis **25:** *b* 2010.22.3,Gift of the Hope School Community Center, Pomaria, SC **26:** *l* 2010.66.126, Gift of Jackie Bryant Smith; *r* 2014.63.63.1 **27:** *tl* 2014.63.63.33; *bl* 2014.63.63.31.1-.2; *cl* 2010.31.5, Gift of Kenneth Victor Young in memory of Thomas McCord, Louisville, Kentucky; *tr* (towel) 2012.46.75.3; *tr* (hanger) 2014.63.63.23.1; *tr* (brush) 2014.63.63.6; *tr* (shoehorn) 2012.75.2, Gift of Descendants of Robert and Georgia Thomas, Pulaski, Tenn **28–29:** 2009.28, Gift of Pete Claussen and Gulf and Ohio Railways **29:** *t* James Di Loreto/Smithsonian Institution **30:** 2011.82.1-.2 **31:** *br* 2007.8; *tl* 2011.168; *tr* 2012.43.1, Gift of Lt. Col. Woodrow W. Crockett **32:** *r* 2014.27.2, Gift of Ginette DePreist in memory of James DePreist **33:** *t* 2015.97.24; *l* 2010.74.147, Gift of Joe Schwartz and Family, © Joe Schwartz **34:** *l* 2010.10, Gift of Dr. Lawrence and Luann Cohen; *br* 2011.117.11.1; *tr* 2012.46.36 **35:** *b* 2011.17.201, Gift of Elmer J. Whiting, III, Photograph by Gertrude Samuels © Paul Oppenheimer; *t* 2011.49.6,© Charles Moore **36:** *t* 2011.49.1, © Charles Moore; *b* 2012.107.22, © Danny Lyon/Magnum Photos **37:** *t* 2011.67.2, Gift of the Family of Charles Moore, © Charles Moore; *r* 2011.9, Gift of Dwandalyn and Roderic Reece in memory of Pauline Watkins Reece, © SNCC; *b* 2011.14.12, © 1965 Spider Martin **38:** *t* 2011.159.3.8, Gift from Dawn Simon Spears and Alvin Spears, Sr.; *2* 2011.159.3.1, Gift from Dawn Simon Spears and Alvin Spears, Sr.; *3* 2010.61.34, Gift of Family of Sarah Elizabeth Wright; *4* 2011.159.3.6, Gift from Dawn Simon Spears and Alvin Spears, Sr.; *5* 2011.159.3.4, Gift from Dawn Simon Spears and Alvin Spears, Sr.; *6* 2011.159.3.7, Gift from Dawn Simon Spears and Alvin Spears, Sr.; *7* 2011.159.3.12, Gift

from Dawn Simon Spears and Alvin Spears, Sr.; *8* 2011.159.3.50, Gift from Dawn Simon Spears and Alvin Spears, Sr.; *9* 2011.159.3.25, Gift from Dawn Simon Spears and Alvin Spears, Sr.; *10* 2011.159.3.15, Gift from Dawn Simon Spears and Alvin Spears, Sr.; *11* 2011.159.3.11, Gift from Dawn Simon Spears and Alvin Spears, Sr.; *12* 2011.159.3.2, Gift from Dawn Simon Spears and Alvin Spears, Sr.; **39:** *13* 2012.28.2, Gift of Ellen Siegel; *14* 2011.105.3, Anonymous Gift; *15* 2011.159.3.77, Gift from Dawn Simon Spears and Alvin Spears, Sr.; *16* 2011.159.3.14, Gift from Dawn Simon Spears and Alvin Spears, Sr.; *17* 2011.159.3.76, Gift from Dawn Simon Spears and Alvin Spears, Sr.; *18* 2011.159.3.33, Gift from Dawn Simon Spears and Alvin Spears, Sr.; *20* 2010.61.47, Gift of Family of Sarah Elizabeth Wright; *21* 2011.159.3.5, Gift from Dawn Simon Spears and Alvin Spears, Sr.; *22* 2013.201.1.17; *23* 2011.159.3.23, Gift from Dawn Simon Spears and Alvin Spears, Sr.; *24* 2012.91.19, Gift of M. Denise Dennis **40:** *l* 2010.19.1; *tr* 2012.173.3ab; *br* 2012.154.55ab, Gift of Carl Lewis Estate **41:** *bl* 2013.126.12, Gift of the Carl Lewis Estate, © International Olympic Committee; *bc* 2013.126.20, Gift of the Carl Lewis Estate, © International Olympic Committee; *tr* 2014.30.2; *br* 2009.27.5; *tc* 2012.62.3 **42:** *r* 2015.231.2; *l* 2014.297.1; *c* 2014.30.4 **43:** *t* 2016.65.1, Gift of Jason Collins; *bl* 2014.30.1; *br* 2015.58.1, Gift of Briana Scurry **44:** *tl* 2013.213.2; *tr* 2016.6.154, Gift from Mae Reeves and her children, Donna Limerick and William Mincey, Jr.; *br* 2010.6.158, Gift from Mae Reeves and her children, Donna Limerick and William Mincey, Jr.; *bl* 2010.6.45, Gift from Mae Reeves and her children, Donna Limerick and William Mincey, Jr. **45:** *r* 2007.3.19, Gift of the Black Fashion Museum founded by Lois K. Alexander-Lane; *l* 2007.3.20, Gift of the Black Fashion Museum founded by Lois K. Alexander-Lane **46:** 2014.276.1, © Mensie Lee Pettway/Artists Rights Society **47:** *l* 2012.155.10, Gift of the Lyles Station Historic Preservation Corporation; *r* 2013.162.11 **48:** *t* 2008.16.1-.3; *b* 2009.42.1ab **49:** 2011.90 **50:** *l* 2014.97.2; *b* 2011.153.6; *r* 2009.42.2 **51:** *tl* 2008.7.4; *tr* 2010.23.3; *b* 2011.137.1, Donation of Charles E. Berry **52:** *l* 2011.83.6, Gift of Love to the planet **52–53:** 2011.83.1.1-.9, Gift of Love to the planet **54:** *b* 2013.149.1.1, Gift of Public Enemy; *l* 2015.132.57, © Gene Bagnato; *tr* 2015.132.71, © Michael Benabib; *br* 2015.132.132, © Michael Benabib **55:** *bl* 2015.132.202, © David Corio; *r* 2015.132.100.1, © Michael Benabib; *tl* 2015.132.125.1, © Michael Benabib **56:** 2007.3.11, Gift of the Black Fashion Museum founded by Lois K. Alexander-Lane **57:** *tl* 2007.3.37, Gift of the Black Fashion Museum founded by Lois K. Alexander-Lane; *tc* 2007.3.35, Gift of the Black Fashion Museum founded by Lois K. Alexander-Lane; *r* 2012.152.1213, Gift of Dow B. Ellis, Playbill used by permission. All rights reserved, Playbill Inc. **58–59:** *all* 2013.245, Photography by Jack Mitchell © Alvin Ailey Dance Foundation, Inc. and Smithsonian Institution, All rights reserved. **60:** 2010.51.1ab **61:** *r* 2013.242.1, Gift of the Fuller Family, © Meta Vaux Warrick Fuller; *l* 2013.164, © Sargent Claude Johnson **62:** 2015.151, Gift of William J. and Brenda L. Galloway and Family, © Estate of Alma W. Thomas **63:** *tl* 2011.70.10, © Whitfield Lovell; *r* 2011.70.1, © Whitfield Lovell; *bl* 2011.70.6, © Whitfield Lovell.

Fisk University: 5: *t* John Hope and Aurelia Elizabeth Franklin Library, Special Collections, Photograph Archives. **Getty: 32:** *r* Getty/Bettman

For permission to reproduce illustrations appearing in this book, please correspond directly with the owners of the works, as seen above. Smithsonian Books does not retain reproduction rights for these images individually or maintain a file of addresses for sources.